T0197534

Death-N-Art

AMY SHIVER

To order additional copies of this book, contact:
Xlibris
844-714-8691
www.Xlibris.com
Orders@Xlibris.com

ISBN: Softcover 978-1-6698-5438-8
 Hardcover 978-1-6698-5439-5
 EBook 978-1-6698-5437-1

Library of Congress Control Number: 2022920670

Print information available on the last page

Rev. date: 11/09/2022

Let's explore death and
spirituality through Art.

Starting with
"The only ride everyone will take".

With our first breath all we are promised
is a last leaving everything in between
to circumstance and determination.

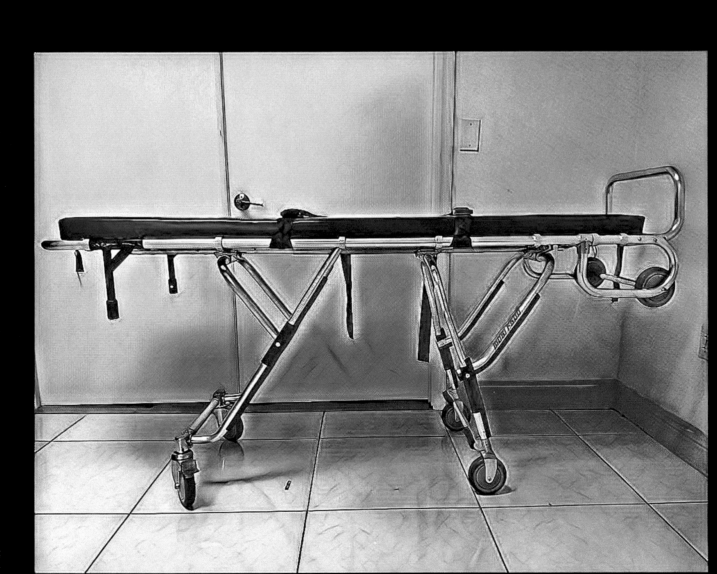

Embalming

Controlled by...

Pressure and Rate of Flow

One of many steps in creating a positive memory picture.

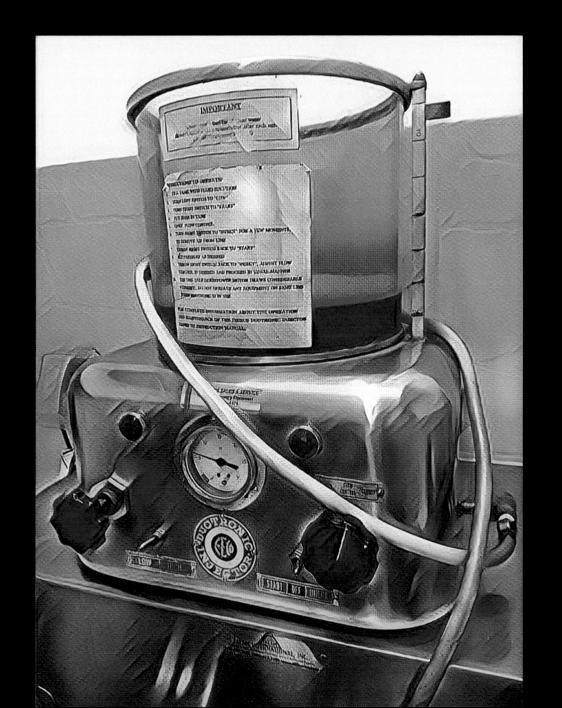

Live your life, it is not a dress rehearsal and caskets do not come with bunkbeds.

The opinion of others is none of your business.

–Respectfully

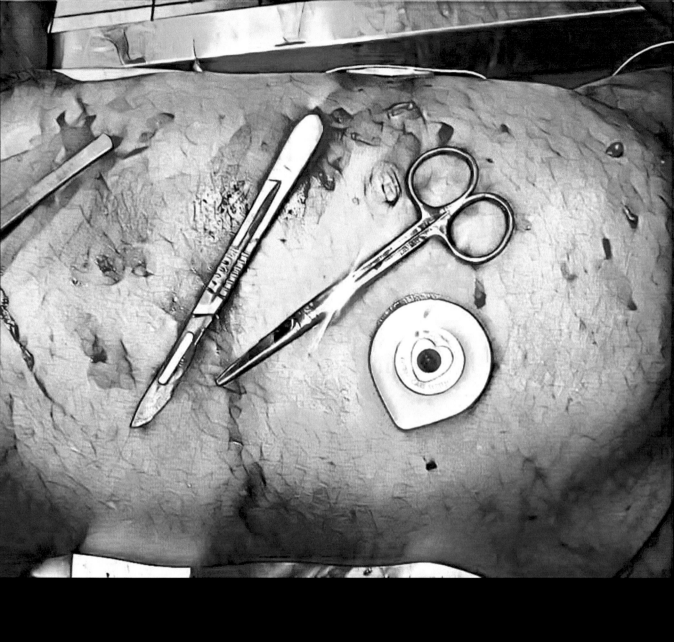

If you knew it was time to take your last breath…

What would you do different?

Do that!

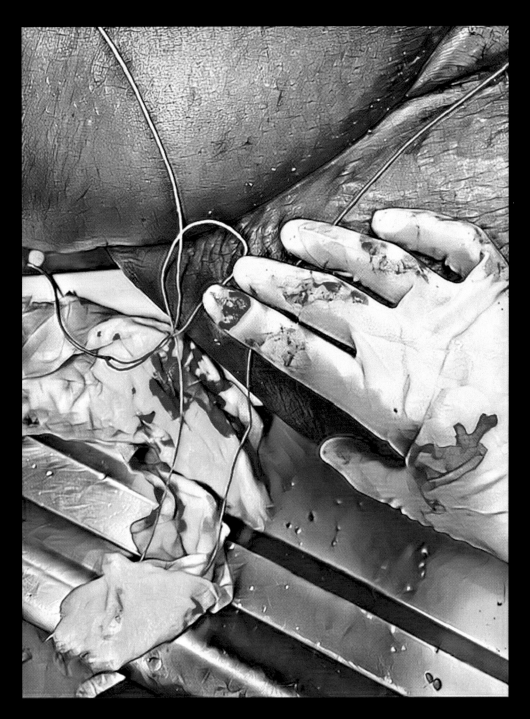

Femoral

Fill through the Artery

Drain through the Vein

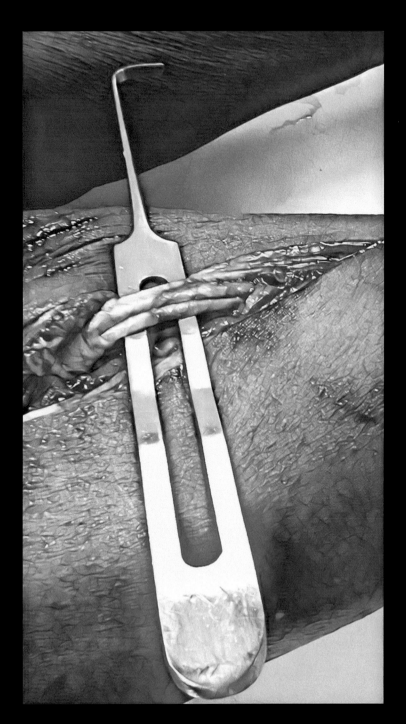

What is something you know that you
need or want to do,
but always put off until tomorrow?

Why not start today?

One day there will be no more
"One Day(s)"

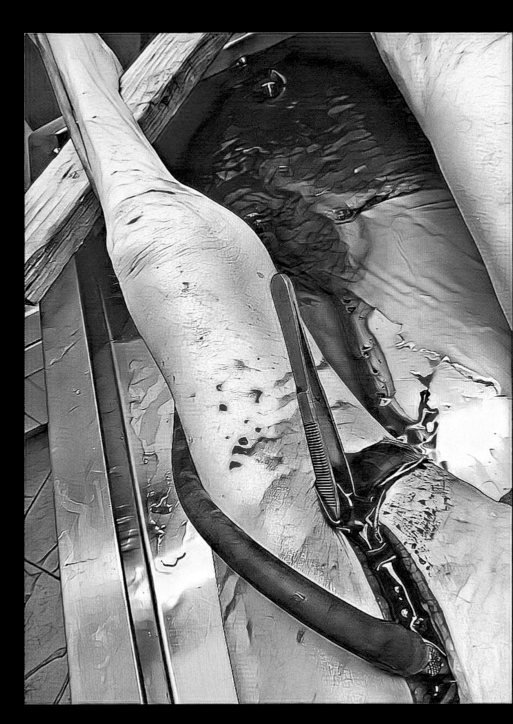

Be unapologetic for your truth and the truth of your spirit.

Many people have both opinion and judgement on things not known.

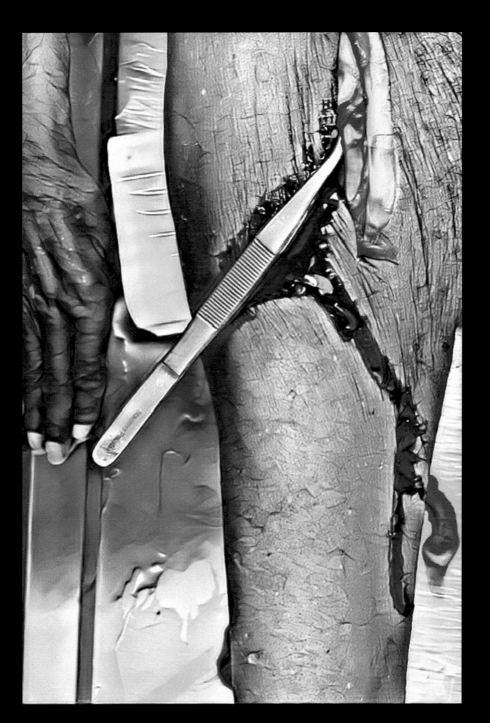

Reflections

Your Life; Your Choices

the consequences are also yours

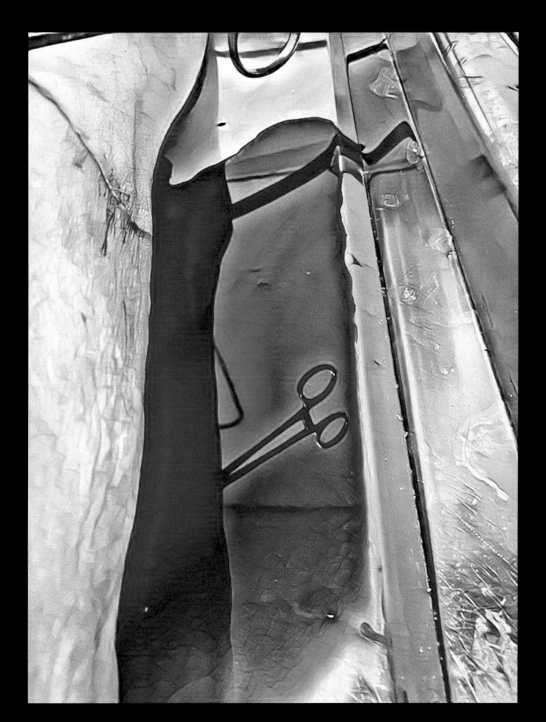

The saint might have been the sinner

had the enticement been any greater.

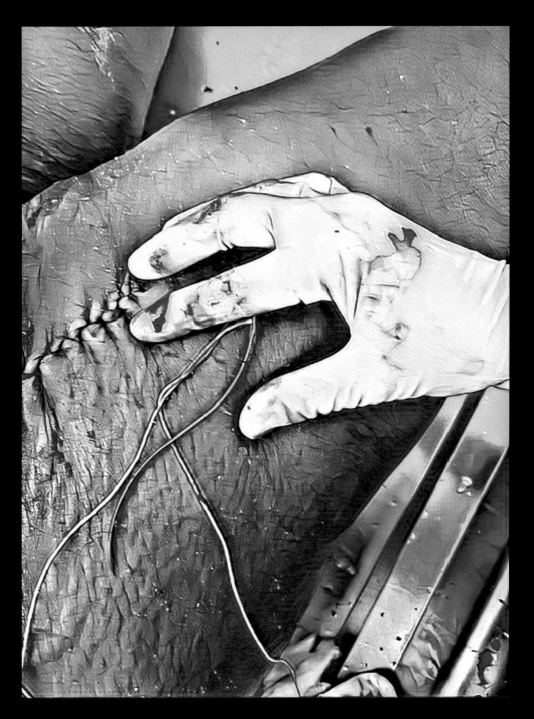

Life has no reset button and when reaction
is based on emotion...

logic will always serve its punishment

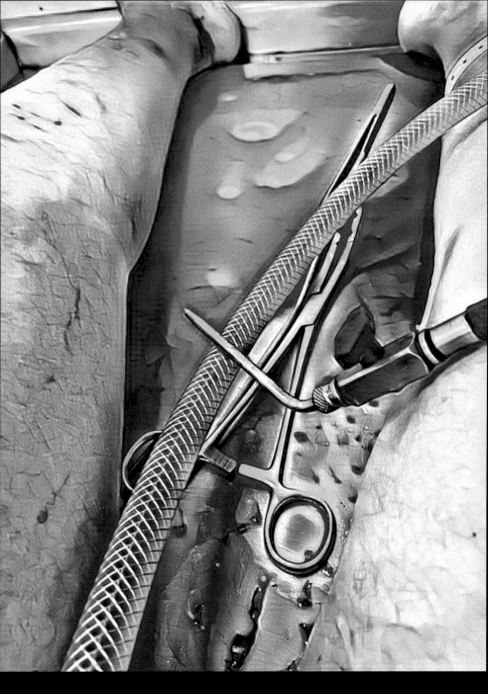

We underestimate our capacity for
suffering until suffering gives us no choice.

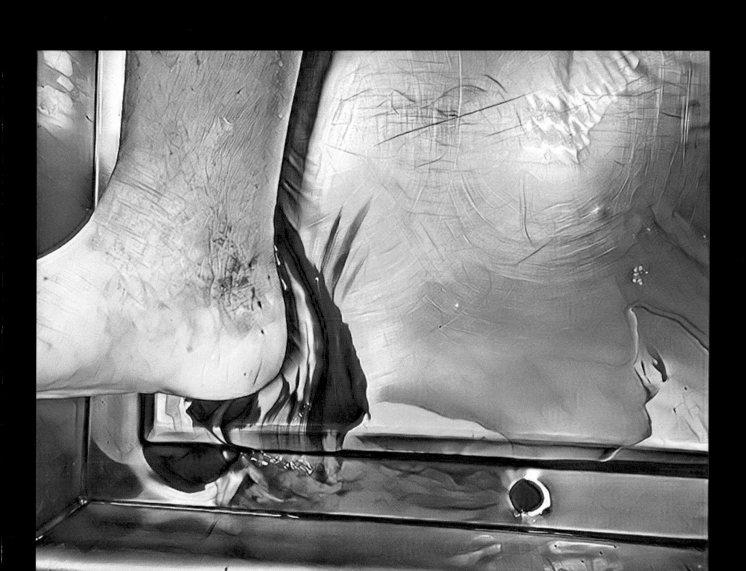

Homeless or Penthouse

Same Stretcher... Same Table...
Same Tools...

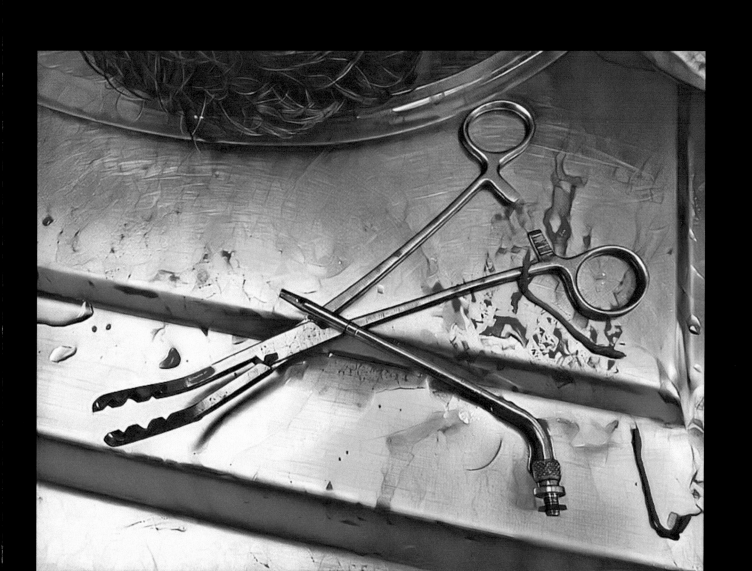

Moments become Memories

Perfectly Imperfect

Speak life into everyone, you never know
their level of broken.

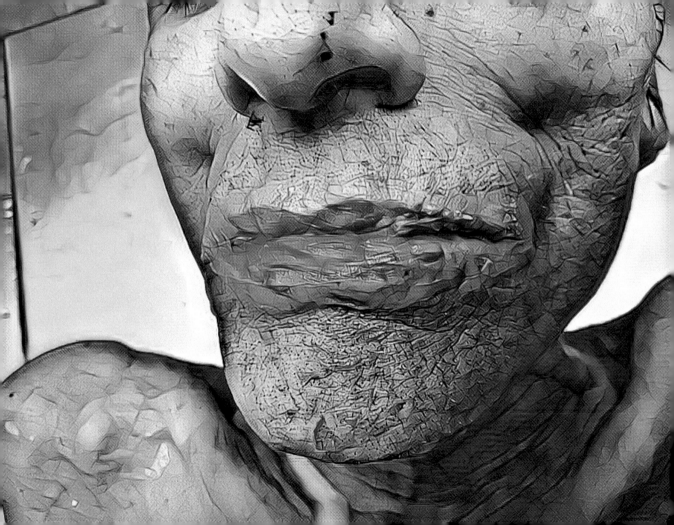

Justice looked within

and saw a torn soul struggled here.

Many thoughts begin through the eyes,

guard them.

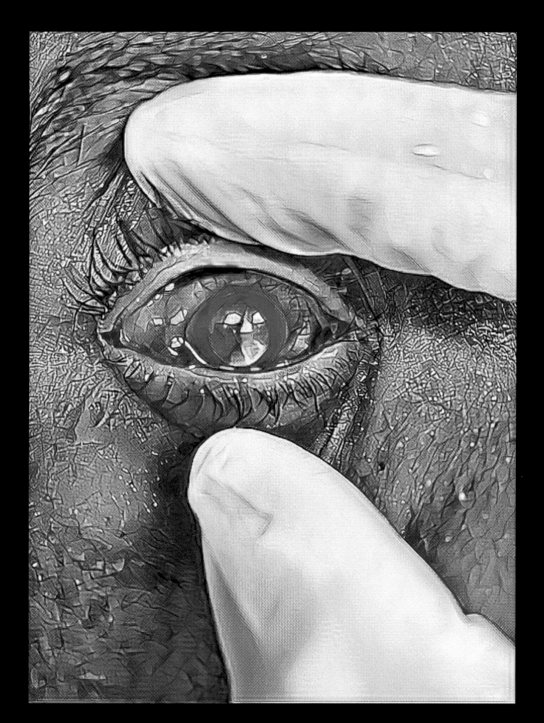

One day

the little things will mean everything

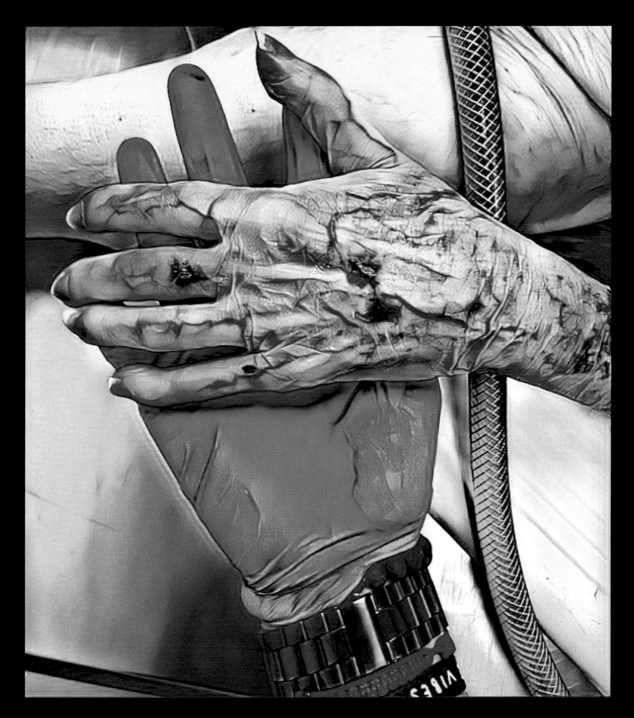

If your feet were never going to touch
ground again…

Where is the last place you want to stand?

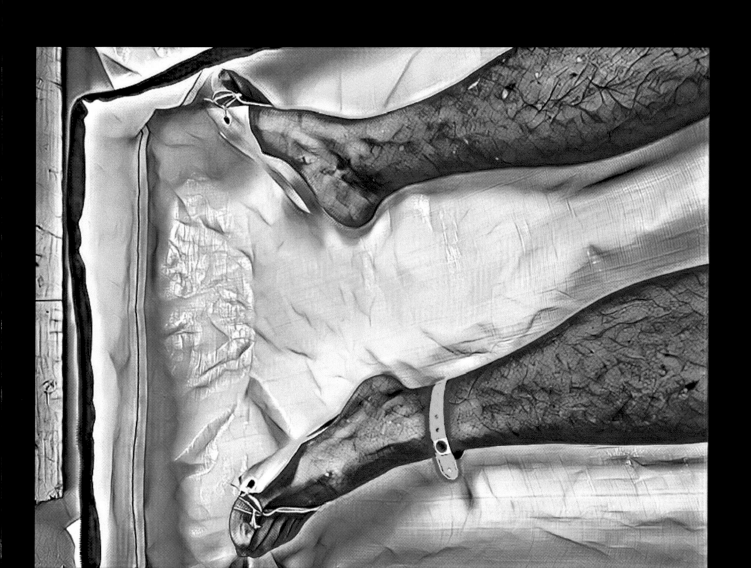

There is no difference between

a wound that will not heal

and a memory that will not die

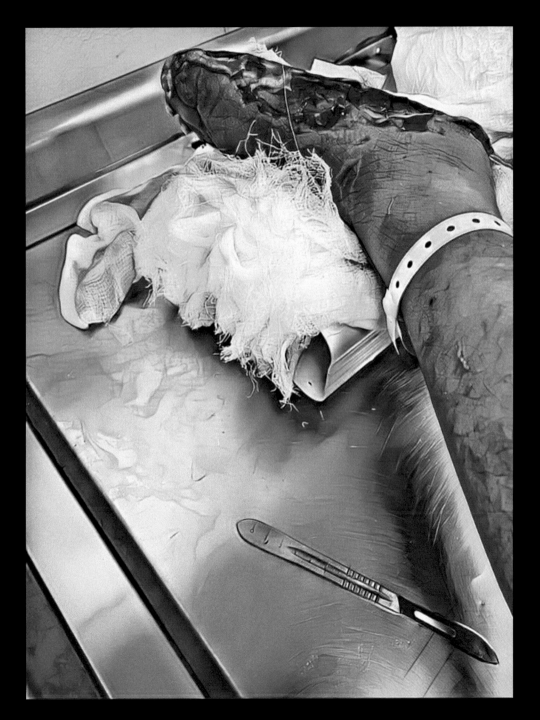

The Brain

our thoughts and deepest secrets

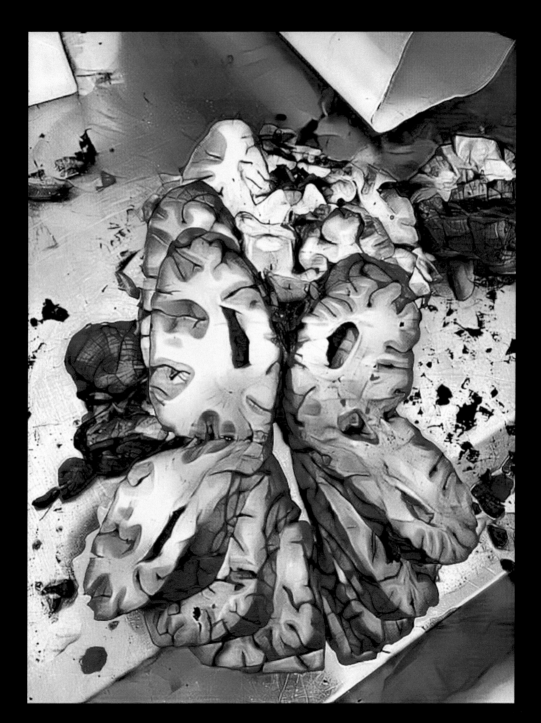

The Heart

felt on so many levels

bringing both tears of joy and pain

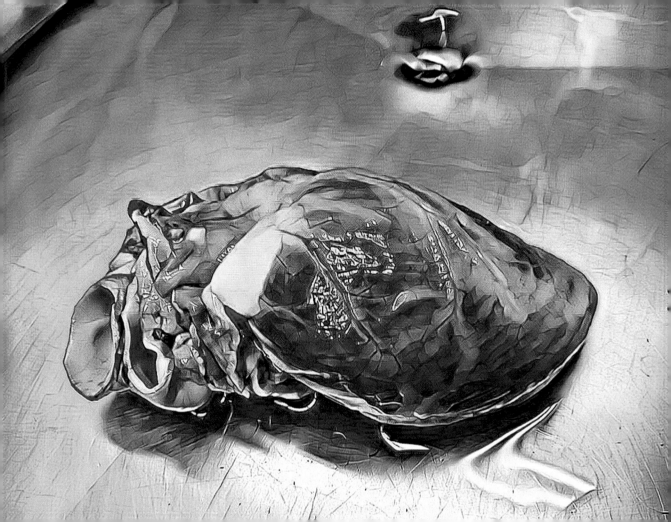

If only...

the head would make the heart
understand

death is as natural as birth

even when it doesn't make sense...

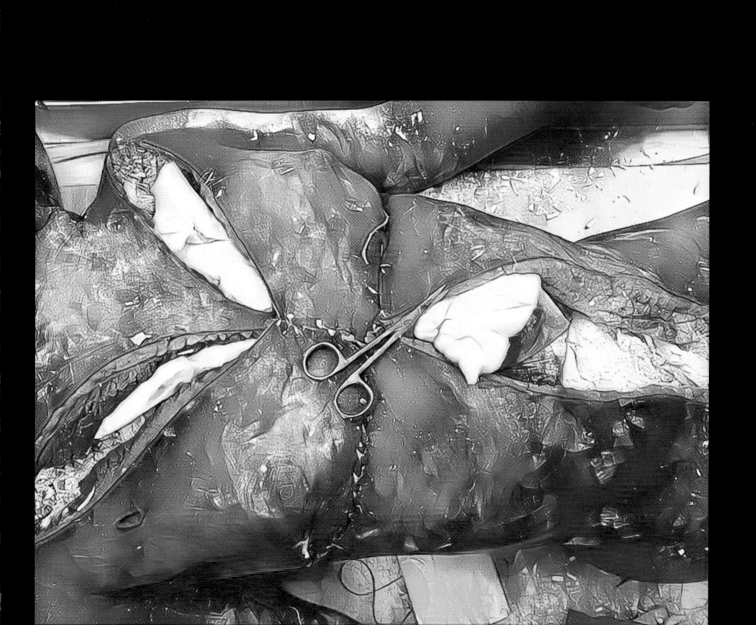

Don't stumble in the same mistake twice...

let the first time be the lesson

Condemnation is not in the act; it is in the repetition.

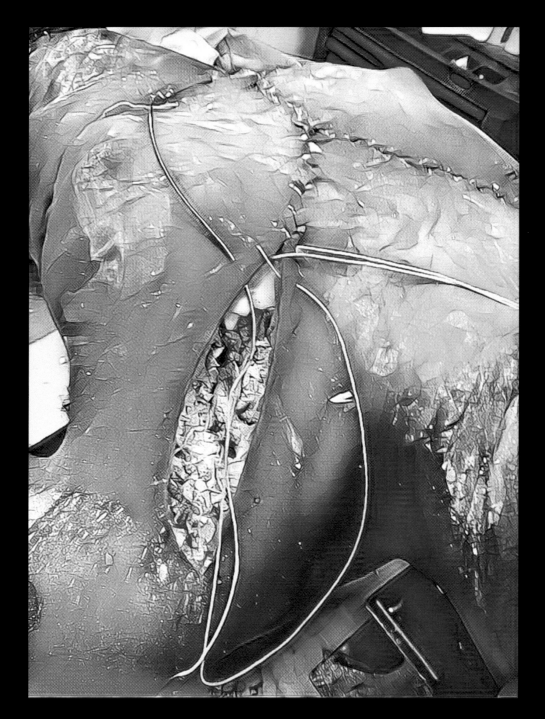

The extent trauma staff goes to save a life

is rarely documented.

What this picture doesn't show is…

the heartache left behind every time

the attempt is not successful

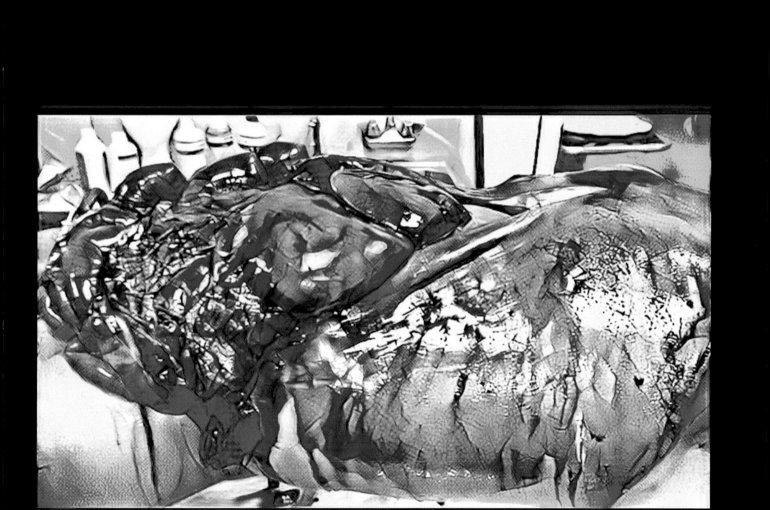

Enjoy each moment fully

and feel each emotion it contains...

SAFELY!

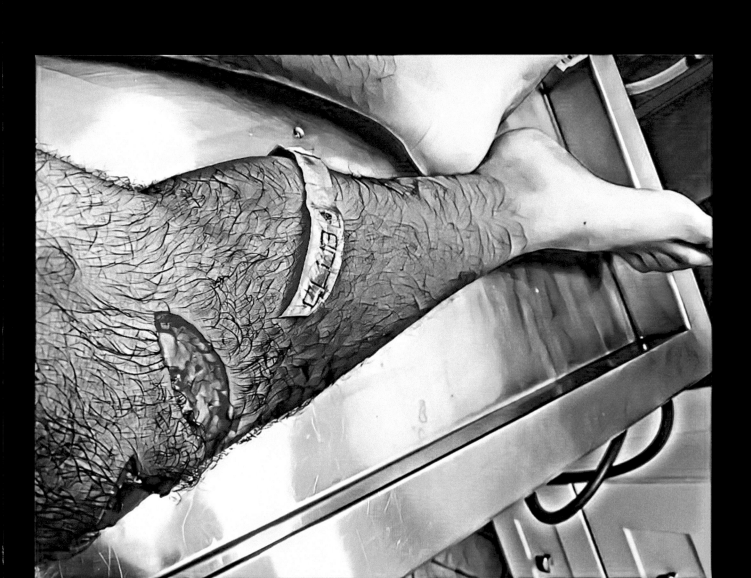

Life has moments of hurting way more
than death.

Don't make permanent decisions from
temporary situations and emotions.

Both joy and pain have seasons…

What is one thing you can do towards your
first step of physical mental and spiritual
freedom?

Suicide Hotline 988

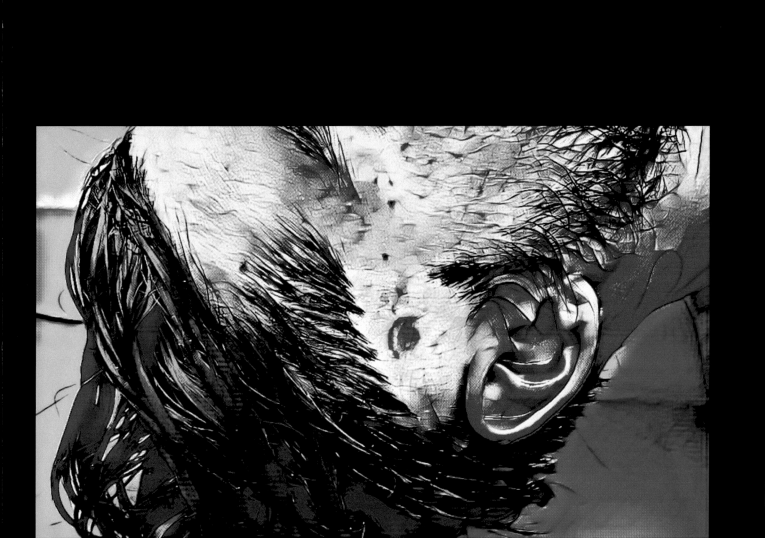

From dust we come

and to dust we shall return.

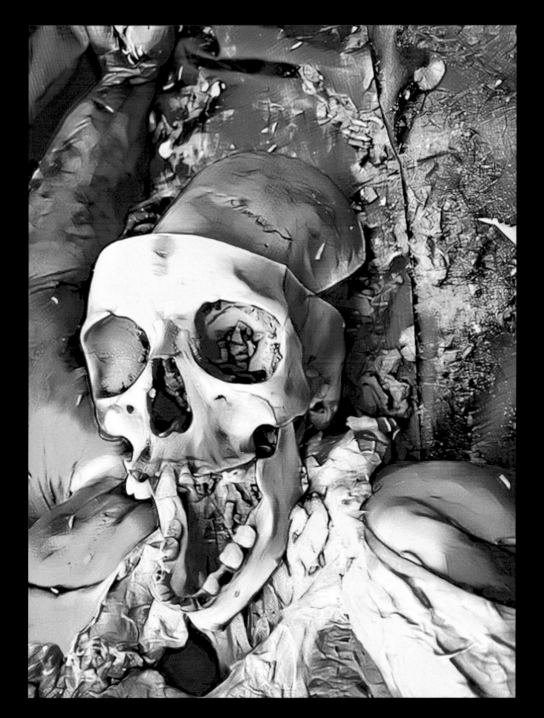

Cremation

the process that solves all problems
death creates

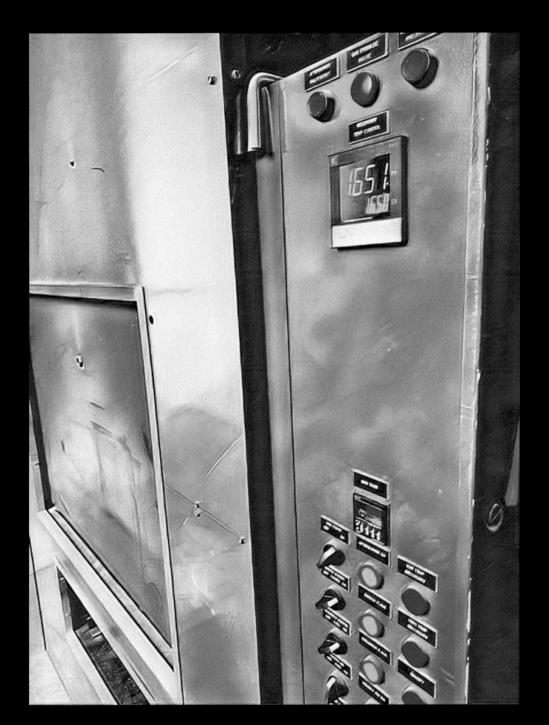

Perspective

Do you see what I see?

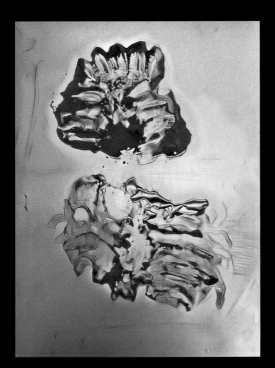

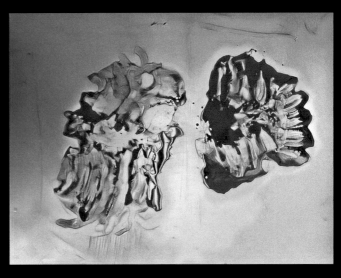

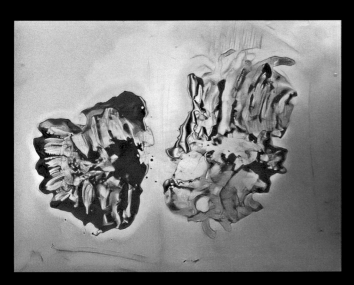

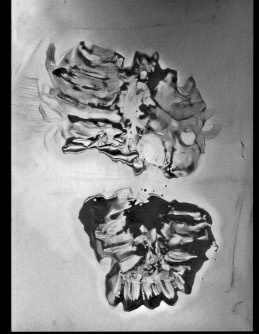

Curiosity leads to education

Death is inevitable and as natural as birth.

Respect life, we are all on borrowed time.

Printed in the United States
by Baker & Taylor Publisher Services